Living Art Lessons

MasterBooks
CURRICULUM

Author: Savannah Barclay

Master Books Creative Team:

Editor: Laura Welch

Design: Diana Bogardus

Cover Design: Diana Bogardus

Cover Photo: @ welcometoourcabin on Instagram - Jeana

Copy Editors:
Judy Lewis
Willow Meek

Curriculum Review:
Kristen Pratt
Laura Welch
Diana Bogardus

First printing: October 2019
Third printing: June 2021

ISBN: 978-1-68344-189-2
ISBN: 978-1-61458-729-3 (digital)

Printed in the United States of America

Please visit our website for other great titles: www.masterbooks.com

Savannah Barclay is a homeschool graduate, world traveler, artist, writer, and explorer of antique shops. She lives in a rural Minnesota town with her husband, Travis, and their new baby boy, Owen. As the daughter of Master Books author Angela O'Dell, she spent her childhood exploring and learning in an out-of-the-box style and discovering and developing her artistic ability and skill. This natural and unhurried approach to education is evident in Savannah's own writing and teaching style.

Your reputation as a publisher is stellar. It is a blessing knowing anything I purchase from you is going to be worth every penny!

—Cheri ★ ★ ★ ★ ★

Last year we found Master Books and it has made a HUGE difference.

—Melanie ★ ★ ★ ★ ★

We love Master Books and the way it's set up for easy planning!

—Melissa ★ ★ ★ ★ ★

You have done a great job. MASTER BOOKS ROCKS!

—Stephanie ★ ★ ★ ★ ★

Physically high-quality, Biblically faithful, and well-written.

—Danika ★ ★ ★ ★ ★

Best books ever. Their illustrations are captivating and content amazing!

—Kathy ★ ★ ★ ★ ★

Affordable
Flexible
Faith Building

Table of Contents

Using This Artist Journal

Features: The suggested weekly schedule enclosed has easy-to-manage lessons that guide the reading and worksheets. The pages of this guide are perforated and three-hole punched so materials are easy to tear out, hand out, and store. Teachers are encouraged to adjust the schedule and materials needed in order to best work within their unique educational program.

Express Yourself: Draw, paint, and create your way through this course as you learn about the seven elements of art! Lines, shapes, colors, value, texture, form, and space — students will learn to find and observe all of these aspects of art in God's beautiful creation, and they will discover how they can imitate His artistry in their own work. Including scavenger hunts for each element and a variety of art projects — from sketching to watercolor painting to sculpting — students will enjoy exploring their own style of art!

	Approximately 30 to 45 minutes per lesson, two days a week
&	**Activity/Art pages for each section**
	Designed for grades 4 to 6 in a one-year course

Course Objectives: Students completing this course will

- Explore the seven elements of art—lines, shapes, color, value, texture, form, and space—through fun and engaging activities and projects.
- Learn types of lines and be able to observe them all around you.
- Determine a variety of shapes as well as positive and negative shapes as they learn how these can be the first step to more complex drawings.
- Discover primary, secondary, tertiary colors; apply the concepts of warm and cool colors, and learn what colors are complementary of each other.
- Experiment with the value of colors (hues and tones) when blended with other colors or water and learn the importance of proper shading.
- Learn how texture is all around and can be incorporated both in sketching and in painting.
- Find out how form impacts shadows, shading, one-, two-, and three-dimensional objects, and how to take a two-dimensional form and draw it as a three-dimensional object.
- Discern how space is important to three-dimensional perspectives using overlapping, changing size, and other techniques.
- Read the stories of famous artists and have fun as you are "re-creating" their styles.
- Enjoy nature while exploring the seven basic art elements as displayed in God's creation.

Course Description

This art course has been written and designed to allow students to explore a range of techniques, styles, and mediums (paints, watercolors, etc). As with any course, *Living Art Lessons* can be modified to fit the needs of your student. Supply lists have been developed to try to reduce the number of specialty items and instead, find materials that can be used in a variety of ways or ones that you may already have on hand. Cost-saving recipes for clay and puffy paint have been included that use common household ingredients if you wish to save money on those items. You can check the course schedule to see when those projects will be done so you can be prepared.

Before You Begin

Make sure the table or countertop where you will be creating your project is protected with newspaper or a disposable tablecloth. Art mediums such as pastels and watercolors may stain whatever they touch, so make sure you are wearing a protective art frock or "paint-shirt" that you don't mind getting spills on. Always make sure your paintbrushes are clean and dry before starting your project, and, so they are ready for their next use, clean them well with warm water and dry them on a paper towel after each project. It is always a good idea to have a well-organized art supply storage area.

On Your Own

As your student learns about the elements of art, they may want to explore more about the concepts and techniques. We have included "On Your Own" opportunities in the course schedule to accommodate students who wish to research more about artists, their paintings, artistic style, or even just observing or practicing what they have learned. They can do research online (with parental permission) or get books from the library related to art interests. This can be considered an optional course component.

A Note About Watercolors: If you want to use watercolors in some of the assignments, it is recommended that you use pages from your mixed media sketch pad.

Supply List

Arts & Crafts Supplies:

☐ Colored pencils (24-pack or more suggested)

☐ Crayons (16-pack or more)

☐ Markers (washable)

☐ Oil, chalk, or crayon pastels

☐ Tempera or poster paint(s) (white, black, and primary colors)

☐ Watercolor paints (including orange and dark green)

☐ Paintbrushes

☐ Paper—1 mixed media sketchpad (suitable wet & dry mediums, including watercolor; smooth, 90lb+ weight paper, 9" x 12", 20 to 40 sheets)

☐ Card stock (3—8½ x 11 or larger)

☐ Tissue paper (blue, green, pink, and white)

☐ Construction paper (various colors)

☐ Erasers

☐ Pencils

☐ Pencil sharpener (small, manual type)

☐ Ruler

☐ Scissors

☐ Fine-tip black pen

☐ Permanent felt-tipped markers (water-based markers will not work)

☐ White school glue

☐ Pipe cleaners

☐ Poster putty

☐ Small sponge

☐ Yarn (any color, 2–3 feet)

☐ Protractor or compass (to make large & small circles; may use bowls, cups, and plates)

☐ Shellac (spray, parental supervision required)

☐ Scotch tape (or generic clear tape)

☐ Sharpie® or black marker

Household Supplies:

☐ Butter knife (for the teacher to use)

☐ Knife (for the teacher to use)

☐ Funnel (optional)

☐ Cookie cutters (various shapes)

☐ Round drinking glass

☐ Mixing bowl

☐ Paper plates or Styrofoam™ plates

☐ Plastic forks

☐ Aluminum foil

☐ Ziploc® bag(s) or resealable plastic bag(s)

☐ Cotton balls

☐ Plastic squeeze bottle (a clean honey bottle will work)

☐ Cardboard pieces (cereal boxes are good for this)

Misc:

☐ Collected "textured" odds and ends (paper, cloth, sandpaper, craft feathers, pipe cleaners)

☐ Nature Guides (optional: assorted kinds—trees, plants, birds, etc.)

☐ Magnifying glass

☐ Binoculars

☐ Backpack

☐ Water bottle

Purchase ready-made or make your own Puffy Paint and Clay

(See recipes included in student book and pages 7-8 of this book)

☐ Clay: You can buy oven-bake clay or other varieties of self-hardening or air-dry clay at any arts and crafts store or in the craft section of most retail stores.

☐ Puffy Paint (green and pink)

☐ 2 cups of salt

☐ 4 cups white flour

☐ 3 cups water

☐ 1 teaspoon alum

☐ 2 to 4 potatoes

☐ Vegetable and fruit pieces (onions, mushrooms, apples, starfruit, etc. optional)

Project Weeks Supply List

Observing Lines – Jellyfish Lines (week 5)

- ☐ White mixed media sketchpad paper
- ☐ Watercolor paint
- ☐ Paintbrush
- ☐ Oil, chalk, or crayon pastels

Observing Lines – Yarn Line Foil Design (week 6)

- ☐ Aluminum foil
- ☐ Cardboard (a cereal box works well)
- ☐ Permanent felt-tipped markers (water-based markers will not work)
- ☐ Yarn (any color, 2-3 feet)
- ☐ Glue
- ☐ Tape
- ☐ Scissors

Observing Shapes – Potato Prints (week 12, parental assistance needed)

- ☐ 2-4 potatoes (depending on number of fruit "stamps" being made; optional: onions, mushrooms, apples, starfruit, celery, etc. can also be used)
- ☐ Tempera or poster paint
- ☐ Mixed media paper
- ☐ Styrofoam™ or paper plates
- ☐ Knife and butter knife (both for only the teacher to use)
- ☐ Cookie cutters (various shapes)

Observing Shapes – Snowy Painting (week 12)

- ☐ Dark blue or black construction paper
- ☐ Construction paper in other colors
- ☐ White tempera or poster paint
- ☐ Paper or Styrofoam™ plates
- ☐ Small sponge
- ☐ Cotton balls
- ☐ Aluminum foil (or white construction paper)
- ☐ Glue
- ☐ Scissors

Observing Colors – Warm and Cool (week 17)

- ☐ Paper (large piece or put two pieces of mixed media sketchpad pages together)
- ☐ Crayons (warm and cool colors)
- ☐ Sharpie® (or dark marker)
- ☐ Pencil

Observing Colors – Colorful Water Painting (week 17)

- ☐ Mixed media sketchpad paper (suitable for wet & dry mediums, i.e. watercolors)
- ☐ Watercolor paints
- ☐ Paintbrush (artist, all-purpose)
- ☐ Water

Observing Value – Valuable Jungle Drawing (week 21)

- ☐ Mixed media sketchpad paper
- ☐ Pencil
- ☐ Colored pencils: dark green, light green, and red
- ☐ Watercolor paints: orange and dark green
- ☐ Black tempera or poster paint

Observing Texture – Puffy Paint Project (week 25)

- ☐ Puffy paint
- ☐ Plastic squeeze bottle (a clean honey bottle will work or Ziploc® or resealable bag(s))
- ☐ Scissors (if using Ziploc® bags)
- ☐ Funnel (optional)
- ☐ Mixed media sketchpad
- ☐ Paper

Puffy Paint Recipe:

- ☐ Bowl
- ☐ 1/2 cup white flour
- ☐ 1/2 cup salt
- ☐ About 1 cup water
- ☐ 4 or 5 teaspoons tempera or poster paint(s) (see step four for color options)

Observing Texture – Layered Water Lilies (week 25)

- ☐ Card stock or mixed media sketchpad paper
- ☐ White school glue
- ☐ Scissors

- ☐ Round drinking glass
- ☐ Blue, green, pink, and white tissue paper

Observing Form – Clay Creations (week 30)

- ☐ Clay: You can buy Sculpey ™ Oven-Bake clay or other varieties of self-hardening or air-dry clay at any arts and crafts store or in the craft section of most retail stores. Or, you can make your own.

Self-Hardening Clay Recipe:

- ☐ 4 cups flour
- ☐ 1 teaspoon alum
- ☐ 1½ cups salt
- ☐ 2 cups water
- ☐ Mixing bowl
- ☐ Resealable plastic bag

Observing Space – One-Point Perspective Art (week 35)

- ☐ Mixed media sketchpad paper
- ☐ Ruler
- ☐ Watercolor paints, markers, or crayons
- ☐ Fine-tip black pen
- ☐ Pencil

First Semester Suggested Daily Schedule

Date	Day	Assignment	Due Date	✓	Grade
		First Semester-First Quarter			
Week 1	Day 1	Read pages 4-7; **Observing Lines;** Basic Straight Lines • Page 10 • *Living Art Lessons* (LAL); Complete Activity • Page 19 • *Artist's Journal* (AJ)			
	Day 2	Basic Curvy Lines • Page 11 • (LAL) • Complete Activity • Page 20 • (AJ)			
	Day 3				
	Day 4				
	Day 5				
Week 2	Day 6	Read Thick, Thin, Solid, Broken, & Parallel Lines • Pages 12-13 • (LAL) • On Your Own			
	Day 7	Complete Activity • Page 21 • (AJ)			
	Day 8				
	Day 9				
	Day 10				
Week 3	Day 11	Read Learning from the Artist; Pablo Picasso's Style • Pages 14-16 • (LAL) • On Your Own			
	Day 12	Create Your Own "Picasso" Pet • Page 17• (LAL) • Complete Activity • Page 23 • (AJ)			
	Day 13				
	Day 14				
	Day 15				
Week 4	Day 16	Read Lines in Nature • Pages 18-19 • (LAL) • On Your Own			
	Day 17	Read Line Scavenger Hunt • Page 20 • (LAL) • Complete Activity • Page 25 • (AJ)			
	Day 18				
	Day 19				
	Day 20				
Week 5	Day 21	**Project Week!** Jellyfish Lines • Complete Steps 1-3 • Page 21 • (LAL)			
	Day 22	Continue Jellyfish Lines project • Complete Steps 4-5 • Page 22 • (LAL)			
	Day 23				
	Day 24				
	Day 25				
Week 6	Day 26	**Project Week!** Yarn Line Foil Design, Complete Steps 1-4 • Pages 23-24 • (LAL)			
	Day 27	Continue Yarn Line Foil Design: Complete Step 5• Page 24 • (LAL); Read Lines, Lines, & Lines • Page 25 • (LAL)			
	Day 28				
	Day 29				
	Day 30				

Date	Day	Assignment	Due Date	✓	Grade
Week 7	Day 31	Read **Observing Shapes**; Very Basic Shapes • Pages 27-28 • (LAL) • Complete Activity • Pages 28-29 • (AJ)			
	Day 32	Read Other Shapes • Pages 29-30 • (LAL) • Complete Activity • Pages 30-31 • (AJ)			
	Day 33				
	Day 34				
	Day 35				
Week 8	Day 36	Read Positive and Negative Shapes • Page 31 • (LAL) • Complete Tracing Your Hand Activity • Page 32 • (AJ)			
	Day 37	Complete Positive & Negative Shapes • Page 33 • (AJ) and page 32 (LAL); Read Page 33 • (LAL)			
	Day 38				
	Day 39				
	Day 40				
Week 9	Day 41	Read Learning from the Artist; Vincent Van Gogh's Style • Pages 34-36 • (LAL) • On Your Own			
	Day 42	Create Your Own "Van Gogh" • Page 37 • (LAL) • Complete Activity • Page 35 • (AJ)			
	Day 43				
	Day 44				
	Day 45				
First Semester-Second Quarter					
Week 10	Day 46	Read All Shapes in Nature • Pages 38-39 • (LAL) • On Your Own			
	Day 47	Creating a fish from shapes • Page 40 • (LAL) • Page 37 • (AJ)			
	Day 48				
	Day 49				
	Day 50				
Week 11	Day 51	Read People and Proportions • Page 41 • (LAL) • Complete Activity • Page 39 • (AJ)			
	Day 52	Read Shape Scavenger Hunt • Page 42 • (LAL) • Complete Activity • Pages 41-42 • (AJ)			
	Day 53				
	Day 54				
	Day 55				
Week 12	Day 56	**Project Week!** Potato Prints • Complete Steps 1-7 • Pages 43-44 • (LAL)			
	Day 57	Snowy Painting • Complete Steps 1- 6 • Pages 45-46 • (LAL)			
	Day 58				
	Day 59				
	Day 60				

Date	Day	Assignment	Due Date	✓	Grade
Week 13	Day 61	Read **Observing Color;** Primary and Secondary Colors • Pages 47-49 • (LAL) • Complete Activities • Pages 45-47 • (AJ)			
	Day 62	Read Basic Tertiary Colors • Pages 50-51 • (LAL) • Complete Activity • Page 49 • (AJ)			
	Day 63				
	Day 64				
	Day 65				
Week 14	Day 66	Read Warm and Cool Colors • Page 52 • (LAL) • Complete Activity • Pages 51-53 • (AJ)			
	Day 67	Read Complementary Colors • Page 53 • (LAL) • Complete Activity • Page 55 • (AJ) • Read pages 54-55 • (LAL)			
	Day 68				
	Day 69				
	Day 70				
Week 15	Day 71	Read Learning from the Artists; Norman Rockwell's Style • Pages 56-59 • (LAL) • On Your Own			
	Day 72	Create Your Own "Rockwell" • Page 60 • (LAL) • Page 57 • (AJ) *Note: Two options; student may choose to do one or both of them.*			
	Day 73				
	Day 74				
	Day 75				
Week 16	Day 76	Read Colors in Nature • Pages 61-62 • (LAL) • On Your Own			
	Day 77	Read Color Scavenger Hunt • Page 63 • (LAL) • Color Scavenger Hunt • Pages 59-60 • (AJ)			
	Day 78				
	Day 79				
	Day 80				
Week 17	Day 81	**Project Week!** Warm and Cool • Complete Steps 1-5 • Pages 64-65 • (LAL)			
	Day 82	Colorful Water Painting • Complete Steps 1-3 • Page 66 • (LAL)			
	Day 83				
	Day 84				
	Day 85				
Week 18	Day 86	Read **Observing Value;** Many Valuable Colors and Experimenting with Value • Pages 67-69 • (LAL) • Complete Activity • Page 63 • (AJ)			
	Day 87	Read A Lesson on Shading • Pages 70-71 • (LAL) • Complete Activity • Page 65 • (AJ)			
	Day 88				
	Day 89				
	Day 90				
		Mid-Term Grade			

Second Semester Suggested Daily Schedule

Date	Day	Assignment	Due Date	✓	Grade
		Second Semester–Third Quarter			
Week 19	Day 91	Read Learning from the Artists; Mary Cassatt's Style • Pages 72-74 • (LAL) • On Your Own			
	Day 92	Create Your Own "Cassatt" • Page 75 • (LAL) • Record the different hues • Page 67 • (AJ)			
	Day 93				
	Day 94				
	Day 95				
Week 20	Day 96	Read Value in Nature • Pages 76-77 • (LAL) • On Your Own			
	Day 97	Read Valuable Scavenger Hunt • Page 78 • (LAL) • Complete Activity • Page 69 • (AJ)			
	Day 98				
	Day 99				
	Day 100				
Week 21	Day 101	**Project Week!** Valuable Jungle Drawing • Complete Steps 1-2 • Page 79 • (LAL)			
	Day 102	Complete Steps 3-5 • Page 80 • (LAL)			
	Day 103				
	Day 104				
	Day 105				
Week 22	Day 106	Read **Observing Texture;** What Is Texture? • Pages 81-82 • (LAL) *Note: An activity has been suggested in the book; it will need parental supervision.*			
	Day 107	Read Experimenting with Texture • Page 83 • (LAL) • Complete Activity • Pages 73-74 • (AJ)			
	Day 108				
	Day 109				
	Day 110				
Week 23	Day 111	Read Learning from the Artists; John Jay Audubon's Style • Pages 84-87 • (LAL) • On Your Own			
	Day 112	Create Your Own "Audubon" • Pages 88-89 (LAL) • Complete Activity • Page 75 • (AJ) *Note: Three options are given; student may choose to do one or more of them.*			
	Day 113				
	Day 114				
	Day 115				
Week 24	Day 116	Read Texture in Nature • Pages 90-91 • (LAL) • On Your Own			
	Day 117	Read Texture Scavenger Hunt • Page 92 • (LAL) • Complete Activity • Pages 77-78 • (AJ)			
	Day 118				
	Day 119				
	Day 120				

Date	Day	Assignment	Due Date	✓	Grade
Week 25	Day 121	**Project Week!** Puffy Paint Project • Complete Steps 1-4 • Pages 94-95 • (LAL) *Note: You can create your own puffy paint for this lesson using the recipe on page 93 or purchase puffy paint.*			
	Day 122	Layered Water Lillies • Complete Steps 1-6 • Pages 96-97 • (LAL)			
	Day 123				
	Day 124				
	Day 125				
Week 26	Day 126	Read **Observing Form;** What Is Form? • Pages 99-101 • (LAL) • On Your Own			
	Day 127	Read Experimenting with Form: 2-D to 3-D • Page 102 • (LAL) • Complete Activity • Pages 81-83 • (AJ) *Note: Save these for the next week's activity.*			
	Day 128				
	Day 129				
	Day 130				
Week 27	Day 131	Read More on Shading and Shadows • Pages 103-105 • (LAL) • Practice Shading and Light Source Activity • Page 85 • (AJ)			
	Day 132	Do a drawing using shading Steps 1-4 with two or more objects • Pages 104-105 • (LAL) *Note: Do this activity in the student's drawing pad or on a large piece of paper.*			
	Day 133				
	Day 134				
	Day 135				
		Second Semester-Fourth Quarter			
Week 28	Day 136	Read Learning from the Artists; Michelangelo's Style - Sculptures 3-D • Pages 106-110 • (LAL) • On Your Own			
	Day 137	Create Your Own Michelangelo • Complete Steps 1-6, Pages 111-112 (LAL)			
	Day 138				
	Day 139				
	Day 140				
Week 29	Day 141	Read Form in Nature - Create a Paper Tree Using Form, Steps 1-9 • Pages 113-115 • (LAL) • Tree Activity Cutouts • Pages 87-89 • (AJ)			
	Day 142	Read Form Scavenger Hunt • Page 116 • (LAL) • Complete Activity • Pages 91-92 • (AJ)			
	Day 143				
	Day 144				
	Day 145				
Week 30	Day 146	**Project Week!** Clay Creations - Hamburger • Complete Steps 1-4 • Page 118 • (LAL) *Note: You can create your own clay for this lesson using the recipe on page 117 or purchase clay.*			
	Day 147	Complete cat and sundae clay creations • Pages 119-120 • (LAL)			
	Day 148				
	Day 149				
	Day 150				

Date	Day	Assignment	Due Date	✓	Grade
Week 31	Day 151	**Project Week!** Clay Creations • Paint your clay creations. *Note: Tempera paint will work well on these.*			
	Day 152	Shellac your clay creations.			
	Day 153				
	Day 154				
	Day 155				
Week 32	Day 156	Read **Observing Space;** Learning and Experimenting with Space: 2-D • Pages 121-123 • (LAL) • Complete Activity • Page 95 • (AJ)			
	Day 157	Read Learning and Experimenting with One-Point Perspective • Pages 124-125 • (LAL) • Complete Activity • Page 97 • (AJ)			
	Day 158				
	Day 159				
	Day 160				
Week 33	Day 161	Read Learning from the Artists; Grandma Moses's Style • Pages 126-128 • (LAL) • On Your Own			
	Day 162	Create Your Own "Moses" Painting Perspective • Pages 129-130 • (LAL)			
	Day 163				
	Day 164				
	Day 165				
Week 34	Day 166	Read Space in Nature • Pages 131-134 • (LAL) • On Your Own			
	Day 167	Read Space Scavenger Hunt • Page 135 • (LAL) • Complete Activity • Pages 99-100 • (AJ)			
	Day 168				
	Day 169				
	Day 170				
Week 35	Day 171	**Project Week!** One-Point Perspective Art • Complete Steps 1-6 • Pages 136-138 • (LAL)			
	Day 172	Complete Step 7 • Page 139 • (LAL)			
	Day 173				
	Day 174				
	Day 175				
Week 36	Day 176	Optional: Art Show Week! Prepare for the student art show/show & tell.			
	Day 177	Host your family and friends for your art show! Present Award Certificate to your student! • Page 101 • (AJ)			
	Day 178				
	Day 179				
	Day 180				
		Final Grade			

observing

lines

Complete the exercise below to help you remember the three basic straight lines.

Draw the lines you have learned about below.

Horizontal

Vertical

Diagonal

Inside the Box! This exercise is designed to help you not only practice drawing lines, but to help in precision, spacing, and quality of the lines. In the first box, draw 5 of the indicated line style. In the second box, draw 10 of the indicated line. And in the third box, draw 20. As you add the lines, try very hard to not draw over or touch the other lines.

Horizontal

Vertical

Diagonal

5

10

20

Put on your thinking cap, Young Artist, and complete the exercise below.

Match the lines with their correct names.

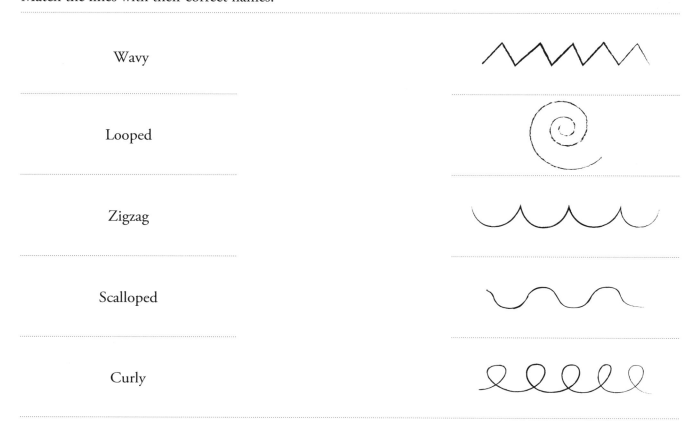

Wavy

Looped

Zigzag

Scalloped

Curly

Funny faces! You have learned a variety of line styles. Add hair and other fun features to these funny faces using the lines you have learned in this course.

Complete the exercise below.

Circle the correct line that matches the description.

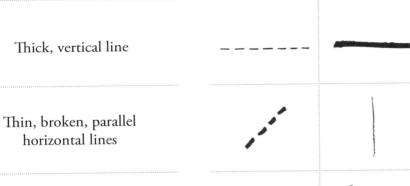

Thick, vertical line

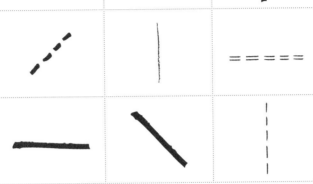

Thin, broken, parallel horizontal lines

Solid (not broken) diagonal line

What are the differences between solid and broken lines?

What is a parallel line?

How do the different line types and thicknesses give artists greater flexibility in their art?

Follow the instructions on page 17 of your student book.

Write examples that you found for each type of line, and be sure to make a couple of sketches of some things you found.

straight lines

Horizontal line:

Diagonal line:

Vertical line:

sketches

curvy lines

Zigzag line:

Wavy line:

Looped line:

Curly line:

Scalloped line:

sketches

observing

shapes

Complete the exercise below to help you remember the three basic shapes.

Draw each shape below:

Circle	Square	Triangle

Label these shapes with the correct lines that make each one. The first line is done for you as an example. Write the shapes' name inside each shape.

When you add these lines together you will get shapes. What shapes will you get? Draw your answers in the boxes.

Example:

 =

 =

 =

 =

Complete the exercise below. Trace over each shape below with pencil and write their names in the blanks.

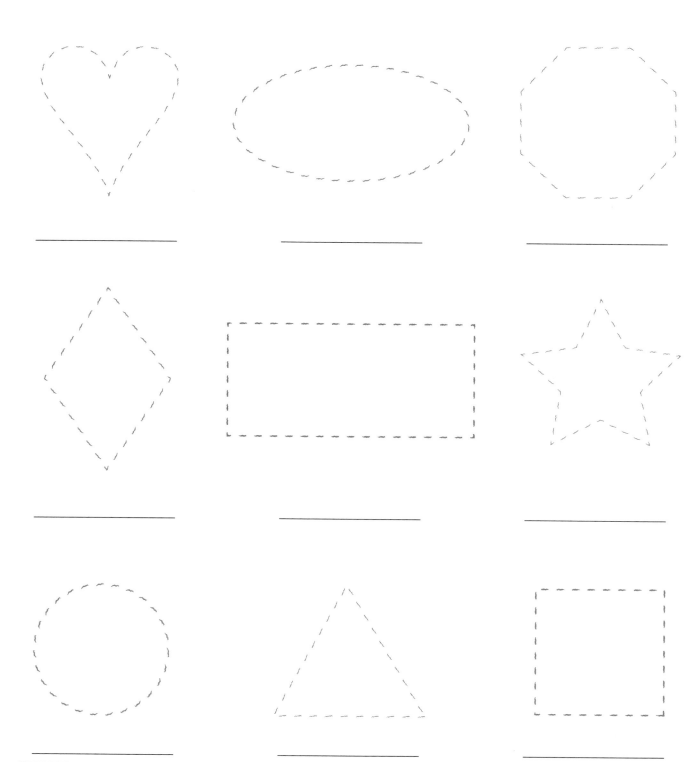

Can you remember these lines? How many sides do these shapes have? What are their names? Trace the shapes.

name _____

name _____

sides _____

sides _____

Complete the panda using the grid below. What shapes do you see when completed?

Use this grid to draw an animal of your choice. Use at least three shapes you have learned to make your image.

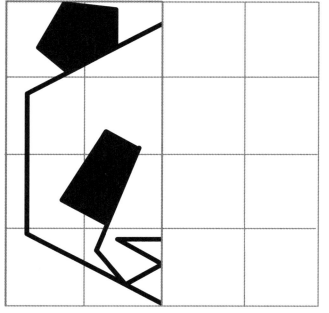

Carefully trace your hand below. Decorate your hand shape with crayons, markers, or colored pencils. Decorate around your hand shape using various shapes.

Follow the instructions on page 32 of *Living Art Lessons* to complete your positive and negative shapes project.

Follow the instructions on page 37 of *Living Art Lessons* to create your own "Van Gogh."

Using the oval as the body of the fish, draw the fins, eye, and mouth of the fish as on page 40 of your student book. Take your time and do your best work! If you want to practice more shapes, use the back of this page to recreate the snake head made from triangles and the dog created from circles. Or you can choose different shapes to draw another animal.

Finish the shape of a person using shapes, based on the image on page 41 of your student book.

Record examples of each shape that you found and make sketches of some interesting examples or objects.

Circles

Squares

Triangles

Multi-shape Challenge!

Find one item that has two or more different shapes. Draw it below:

observing

color

Using crayons or colored pencils, fill in the colors on your color wheel below.

Using crayons or colored pencils, color in each box below with the correct color. Colors can sometimes represent feelings (blue for sad, yellow for cheerful). Write three words that describe feelings that you have related to these primary and secondary colors.

Red

Yellow

Blue

Orange

Green

Purple

Color each box the first color noted and then color on top of that with the second color. (ex. Color it red, then orange.) You will switch this order to color the second box. Refer to page 51 of your student book to see examples of the colors.

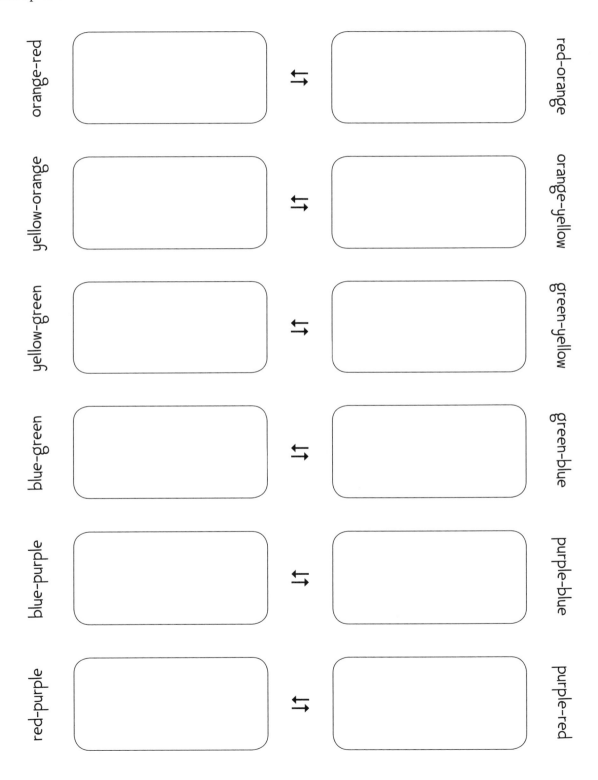

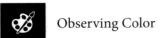
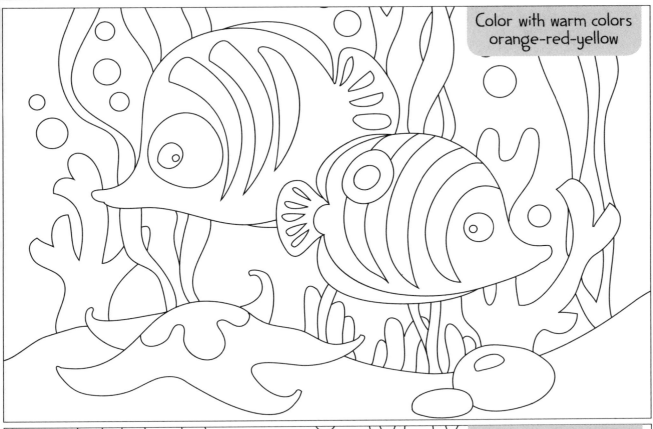

Color with warm colors orange-red-yellow

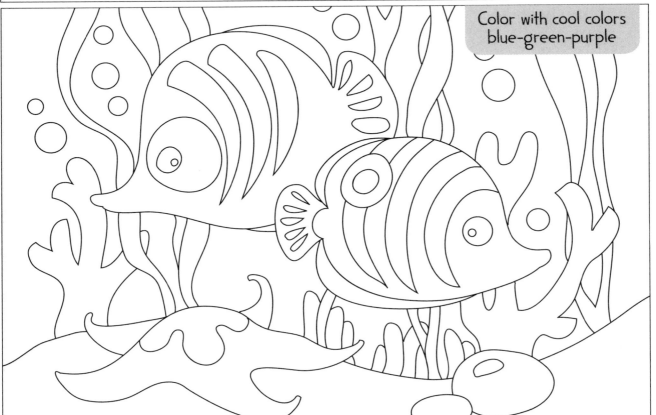

Color with cool colors blue-green-purple

Color with warm and cool colors

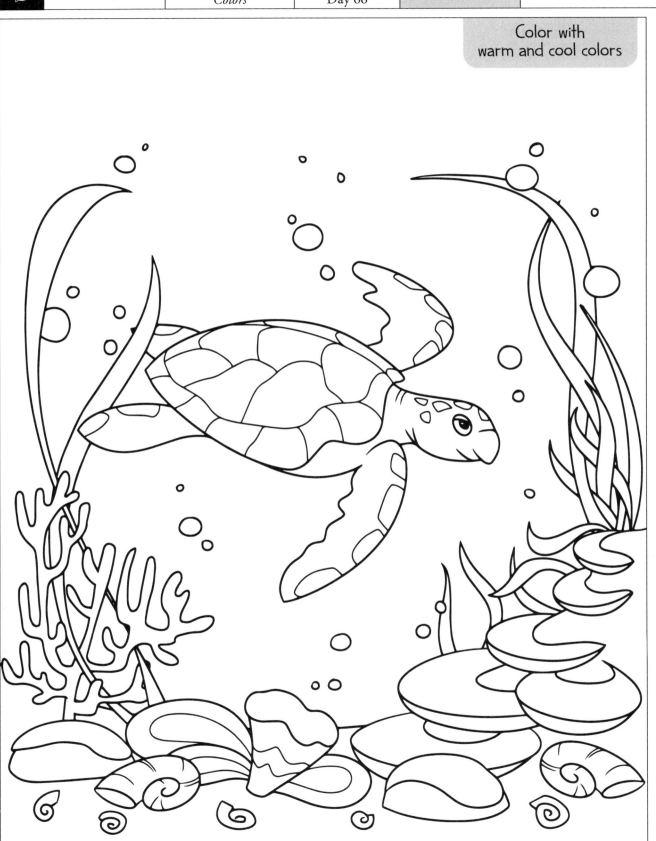

Using complementary colors, color in this drawing.

Red

Purple

Orange

Blue

Yellow

Green

Colorful objects I discovered:

Red: _____ Green: _____

Orange: _____ Blue: _____

Yellow: _____ Purple: _____

A Multi-color Challenge! Have some fun on a color-ful safari. Using what you have learned in Observing Colors, add color to the giraffe below using crayons, markers, or colored pencils. Don't color it like you would normally see it, but instead, use as many colors as you want on the giraffe and its spots to create something new and unique!

observing

value

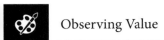
Tempera paint only! Refer to page 69 in the student book for an example. Mix your paint on paper plate, then paint in the circles on this page.

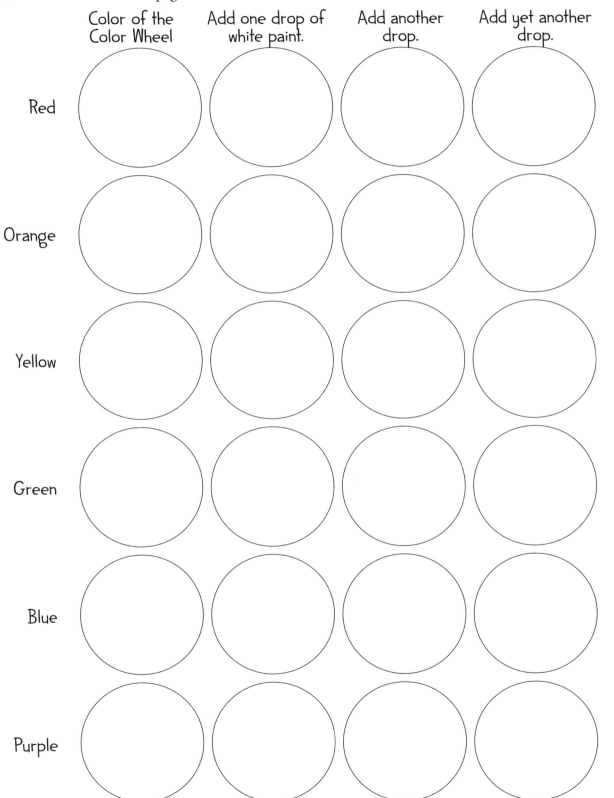

	Color of the Color Wheel	Add one drop of white paint.	Add another drop.	Add yet another drop.
Red				
Orange				
Yellow				
Green				
Blue				
Purple				

Learning to create shading means learning to control your pencil. This means controlling the amount of pressure you use in making marks and being able to start and stop as needed. See page 70 of the student book for more details.

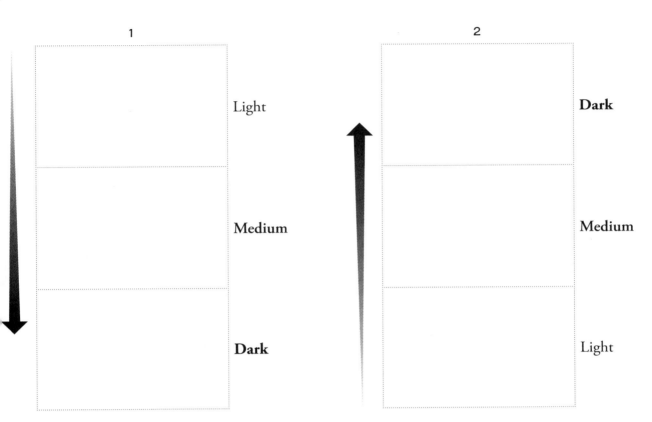

1

Light

Medium

Dark

2

Dark

Medium

Light

Keep practicing.

Using your tempera paints, keep a record of the hues you created in creating your "Cassatt" using the instructions on page 75 of your student book.

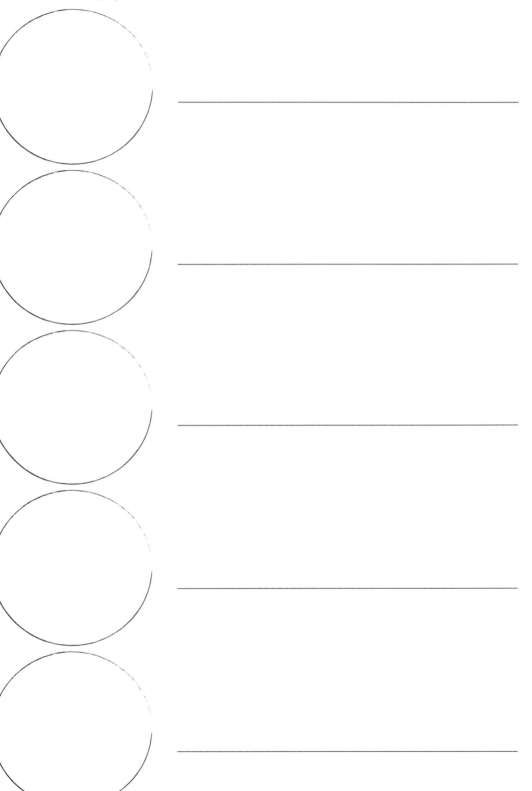

What valuable object did you find?
How many values and hues did you see?

Where did you find this object? What is the object? How many values does it have?

How many valuable objects did you see?
Were you surprised to see so many things with many values?

observing

texture

Complete this activity using the instructions on page 83 of your student book. Then, record the results from your 2-minute texture challenge on the following page.

2-minute Texture Challenge! See how many different textures you can find within arm's reach right where you are sitting. List what you found:

1.

2.

3.

4.

5.

6.

7.

8.

9.

10.

Choose one or more of the options on pages 88-89 in your student book to Create Your Own "Audubon." If you want to do more than one option, either copy this page of your Artist's Journal or trace the owl image onto another sheet of paper.

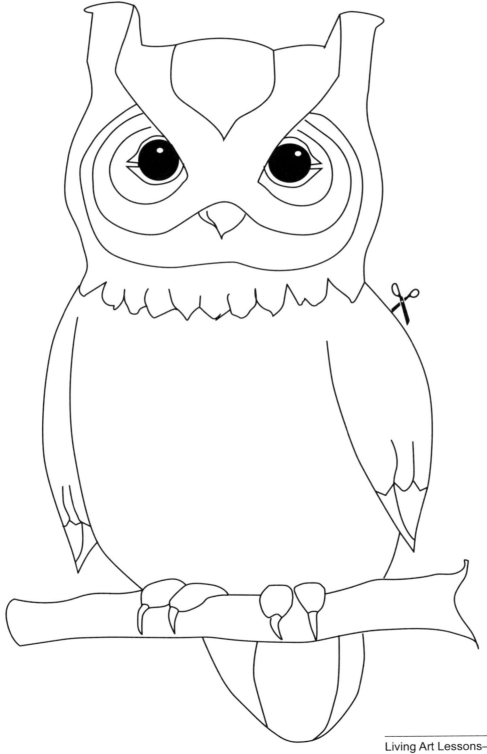

| | Observing Texture | *Texture Scavenger Hunt* | Week 24 Day 117 | Activity Page | Name |

Find four textured objects. Take a photo of each and add them to this page and the next, or draw the textures of the objects that you found in the spaces below. Then answer the questions.

sketches

I found: _____

sketches

I found: _____

Which of these two textures is your favorite? _____

What words would you use to describe the texture? _____

sketches

I found: _____

sketches

I found: _____

Which of these two textures is the roughest?_____

Can you identify any shapes within the texture? _____

observing

form

Pyramid

Follow the instructions below to turn your two-dimensional pyramid into a three-dimensional one.

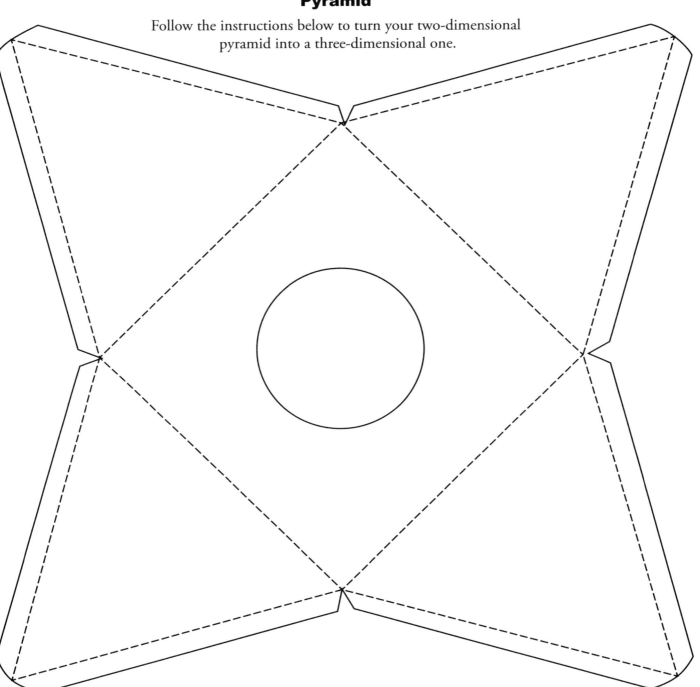

1. Cut out around the 2-dimensional shape.
2. Cut out the circle in the center.
3. Fold along the dashed lines
4. Fold and glue the wings together. Reach through the circular hole to make sure the glues stays intact.

Save the completed pyramid for an upcoming project.

Cube

Follow the instructions below to turn your two-dimensional cube into a three-dimensional one.

1. Cut out around the 2-dimensional shape.

2. Fold along the dashed fold lines.

3. Fold and glue the wings together. Save the completed cube for an upcoming project.

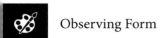
NOTE: It is important to first experiment with the 3-D shapes you made and the light source, turning the objects so the light hits each at different angles, before you do any drawing. You can even experiment with the height of the light source, holding it at different levels to see how it hits the object and changes the shading and shadows. When you are comfortable with the concepts, follow the instructions on pages 104-105 in your student book to complete your shading and shadows activity below.

Create a paper tree using form. Before you begin, carefully read through the instructions on pages 113-115 in your student book. Then starting on page 113, follow the instructions using the cutouts on the following pages to complete the project.

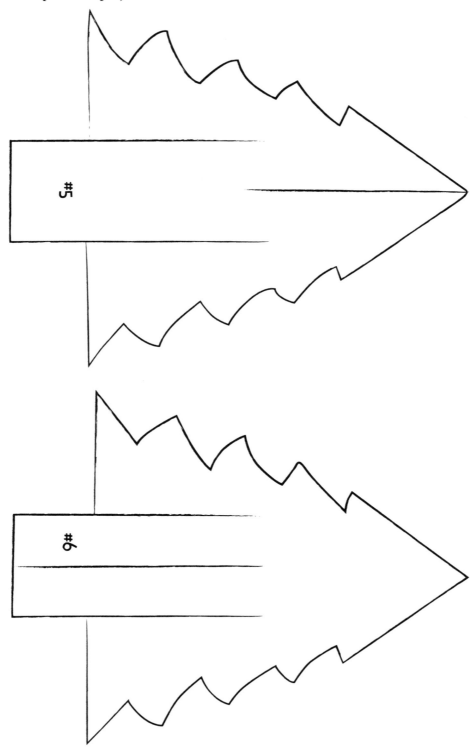

#5

#6

Create a paper tree using form. (continued)

#1

#3

#2

#4

Find objects in nature that have form. Sketch at least two of the objects you found and make sure to include shading and shadows in your drawings. Write a sentence about each of them, noting where you found them and what was interesting about each object. Do the first object on this page. Do the second object on the next page. Take your time and do your best work!

I found: _____

I found: _____

observing

space

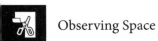
Learn about space in your overlapping collage. Cut out the circles below and follow the instructions on page 123 of your student book.

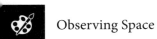
Follow the step-by-step instructions on page 125 of your student book. Don't forget to add shading and shadow to the objects you draw. Note: It's okay to practice this activity in your sketchpad or your art journal page until you master the technique.

Sketch or take pictures of what you find in your Space Scavenger Hunt. Describe on these pages what you found and write about how understanding space helps you to understand what you see. Helpful tip: if you don't want to use a camera and print out what you have found, you can still use a camera or a cell phone to practice focusing on one object and see how that affects the images behind or beyond it.

sketches

I found: _____

sketches

I found: _____

sketches

I found: _____

sketches

I found: _____

Award Certificate

This certifies that

**has successfully mastered the seven elements of art
and produced unique, artistic creations
in a variety of styles and mediums.**

Date: _____

Awarded by: _____